COLORING AND ACTIVITY BOOK

COLORING AND ACTIVITY BOOK

40 Ways to Stop Freaking Out

Julie Jackson
Illustrations by Chris Piascik

Bluestreak
BOOKS

Introduction

Do you need a break? Whether it's too many responsibilities at work or home or your mind is overloaded by the news of the day, please take some time to stop freaking out.

With this book, we give you permission to take a break and cut loose for a while. This is not a book you put on the shelf and leave in perfect condition, it's meant to be wildly interactive. So color outside the lines, cut parts out, fold, throw things—tear it up and make it your own! No one else brings the same frustrations and creative angle to it that you do. Consider it your therapy project and an escape from the pressures of the day.

Most importantly, SHARE. Share the results with co-workers by adding your boss' face to a finger puppet and re-enacting office incidents (bonus points for using Facebook profile pics). Unleash your inner futurist with the magic cat fortune teller. Or color and tear out one of the illustrated phrases to hang at your desk and remind you to smile now and then.

Go ahead and turn your world upside down for a while. Release the therapeutic value of play and be the bad kid in class you always wanted to be. Color on the walls, there are no consequences here.

Embrace the delicious thrill of so-called "bad" words, no one is shocked any-more. By coloring them in, you take away their power. And really, fuck anyone who can't take a joke.

Above all, have fun! Tear it up!

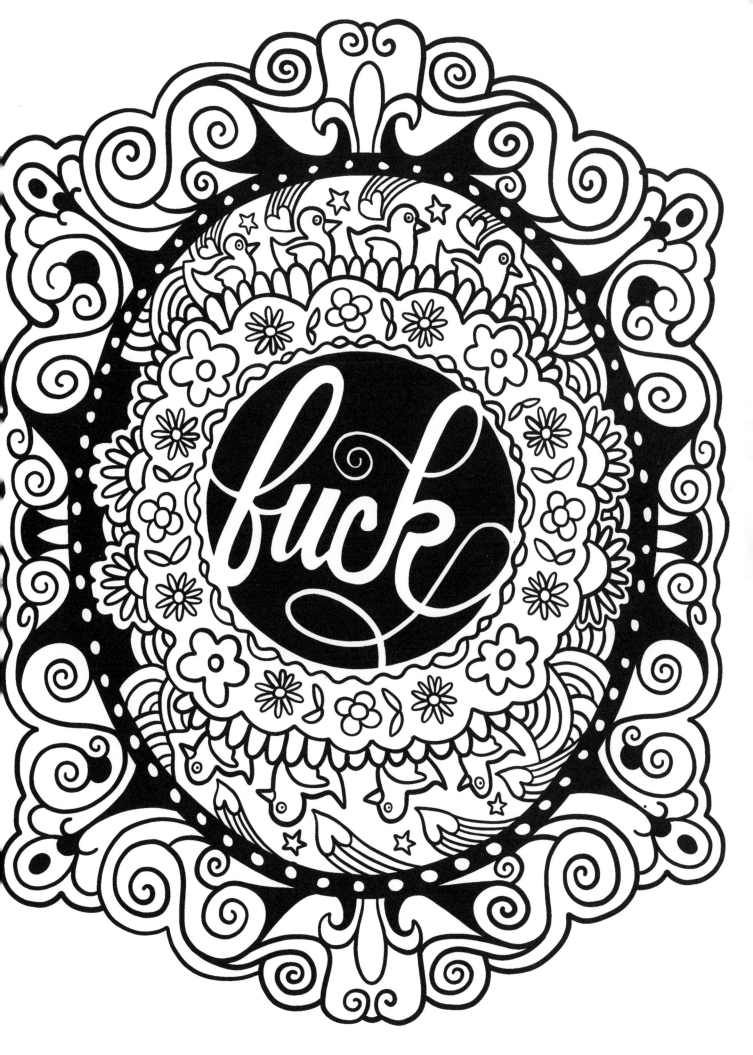

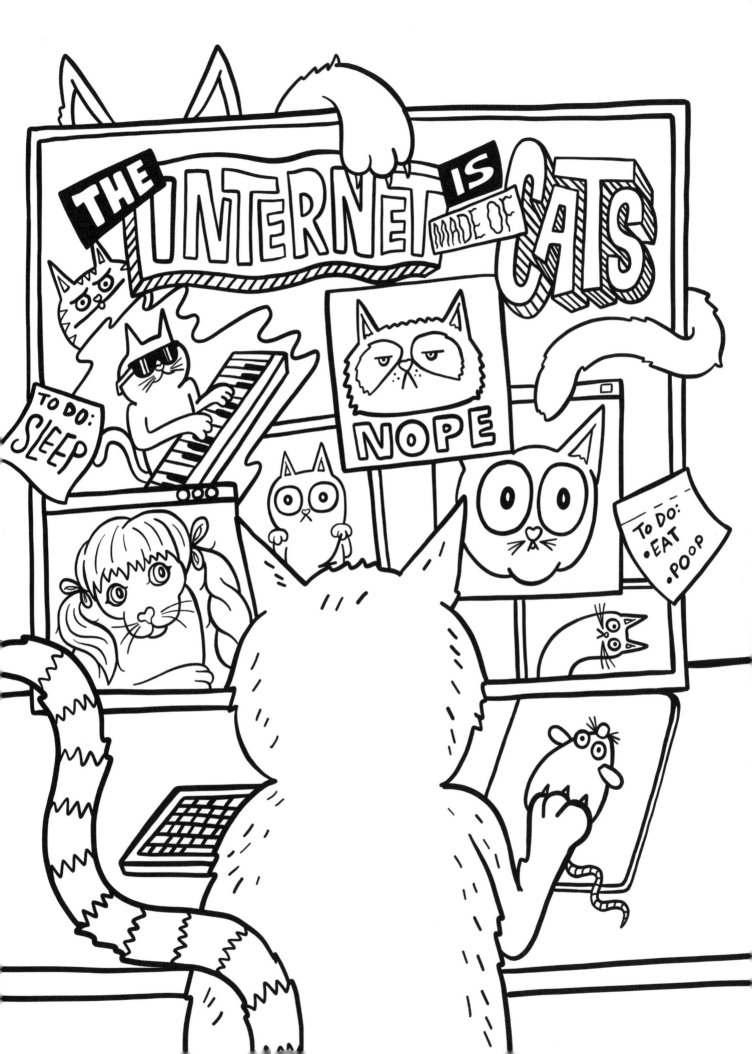

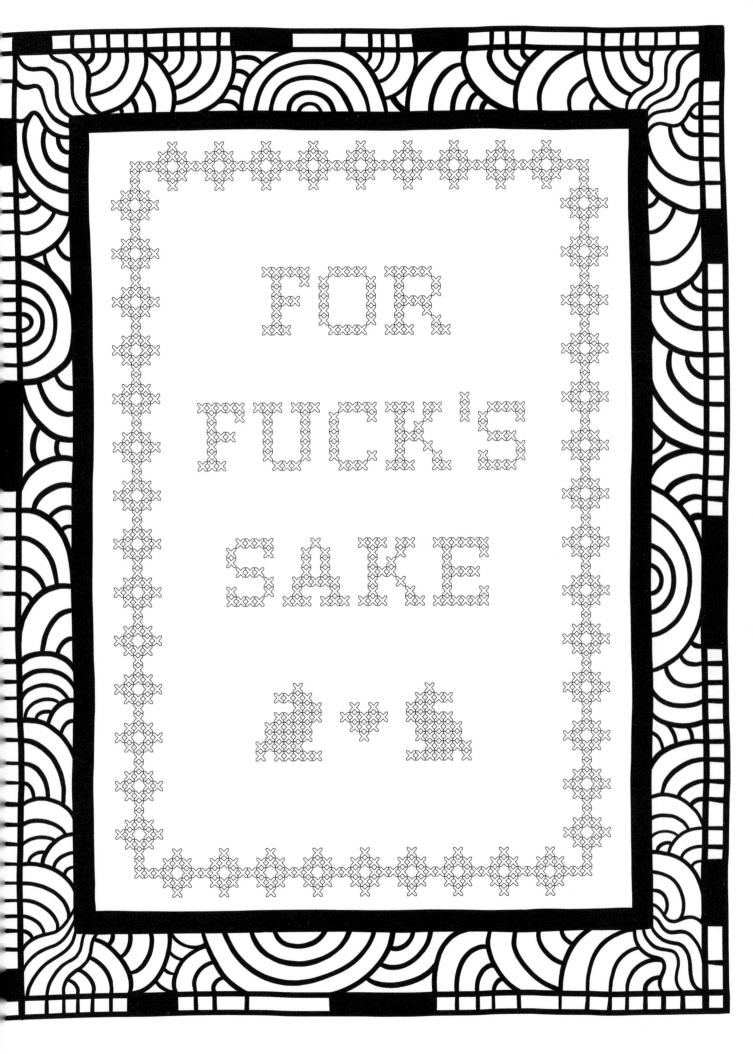

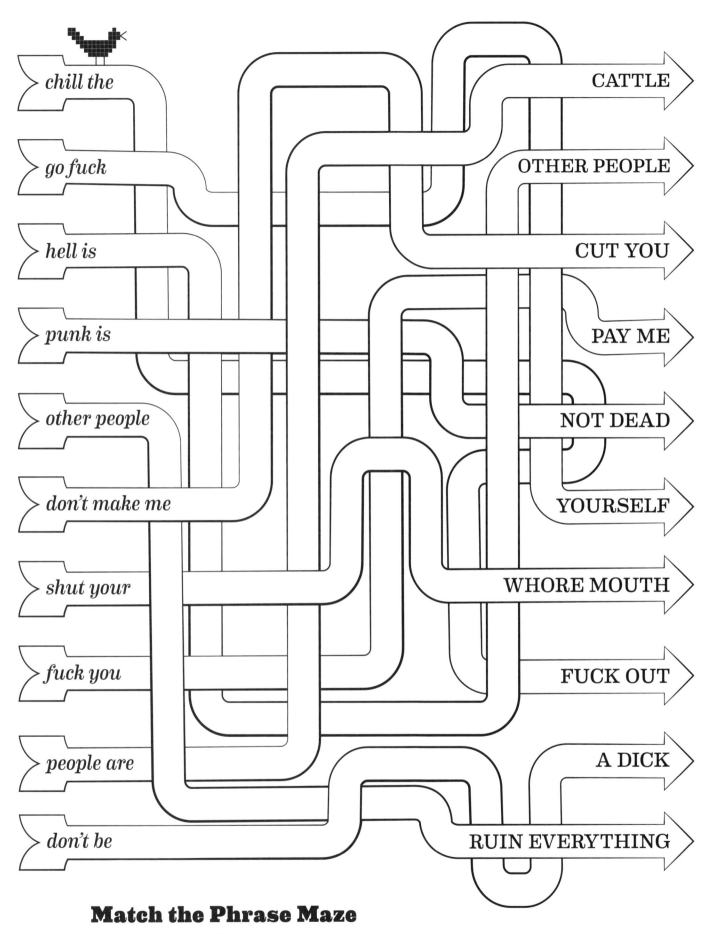

chill the

go fuck

hell is

punk is

other people

don't make me

shut your

fuck you

people are

don't be

CATTLE

OTHER PEOPLE

CUT YOU

PAY ME

NOT DEAD

YOURSELF

WHORE MOUTH

FUCK OUT

A DICK

RUIN EVERYTHING

Match the Phrase Maze

Connect the first half of the phrase at left to the correct one at right.
Or mix them all up and make new phrases of your own. There is no
right or wrong, only weird outcomes unique to your subconscious.

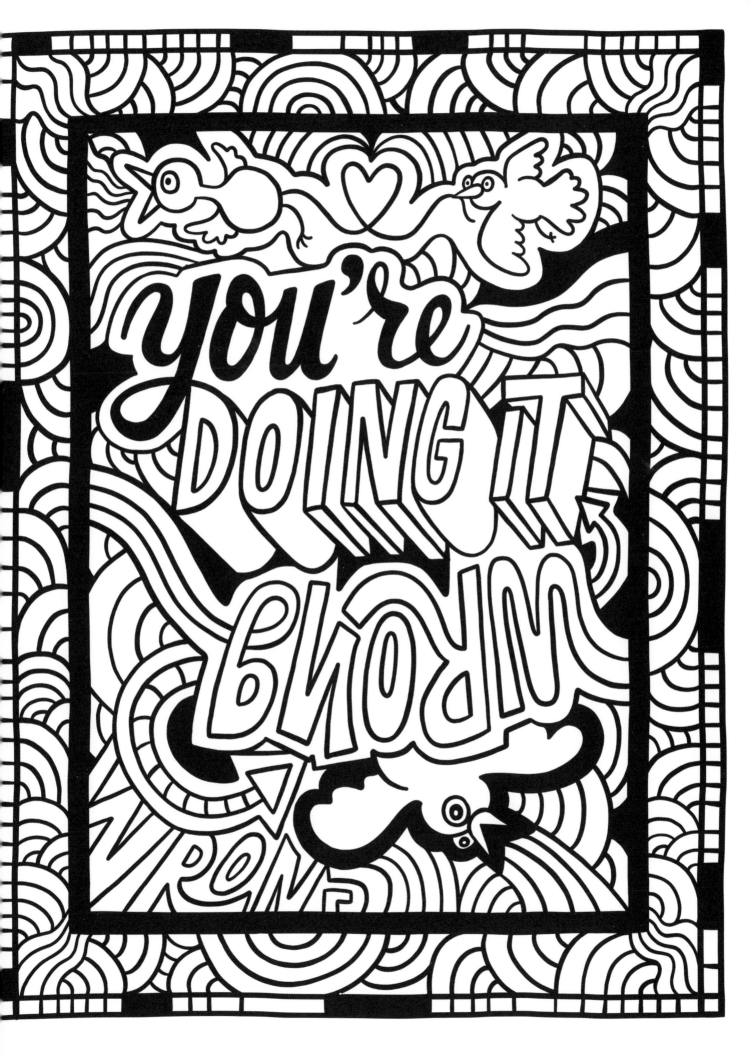

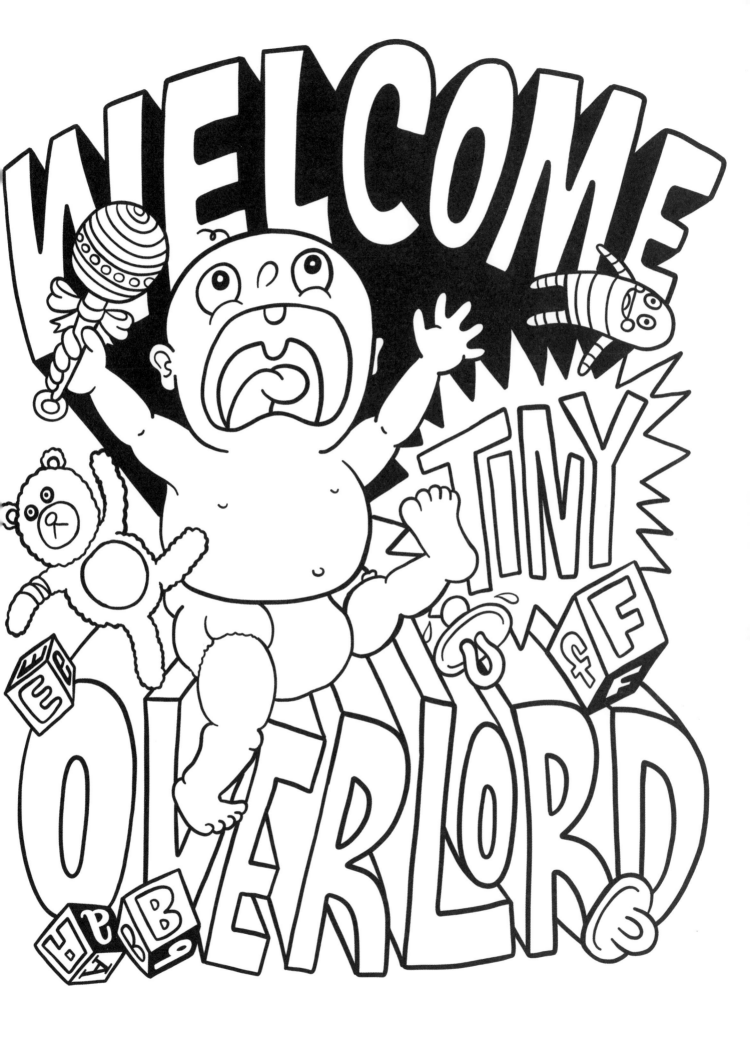

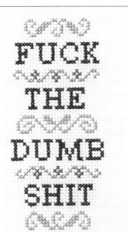

FUCK THE DUMB SHIT

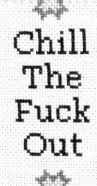

Chill The Fuck Out

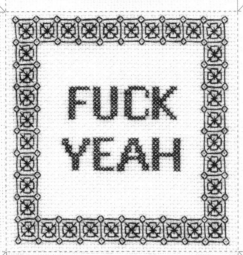

FUCK YEAH

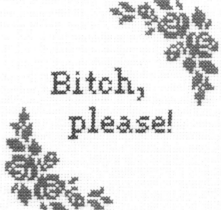

Bitch, please!

YOU'RE DOING IT WRONG

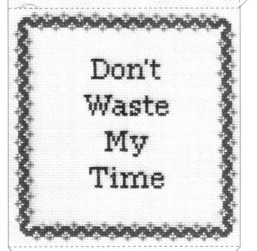

Don't Waste My Time

Magic Subversive Decision Maker

Looking for advice?
Unsure about your next move?

Cut out this little gem, fold under the tabs, tape at the edges and it's ready to go. Hold it in your hot little hands and concentrate on what troubles you. Shake, shake, shake while chanting "Oh, Subversive Decision Maker, enlighten me!" Now toss the decision maker and find your way forward.

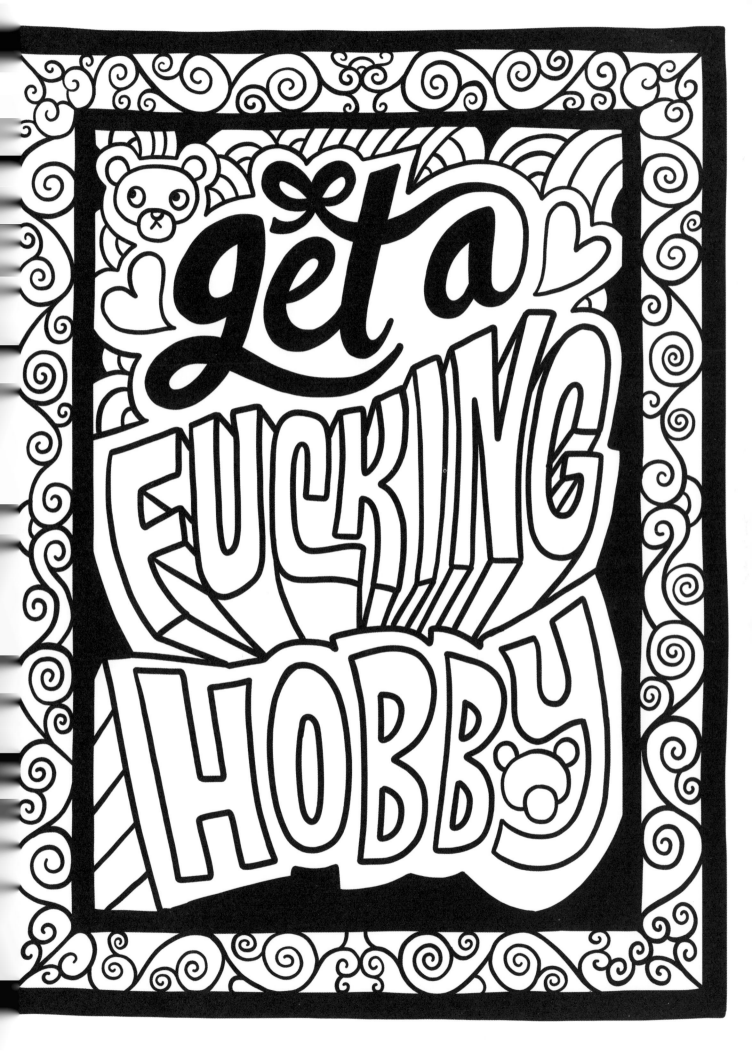

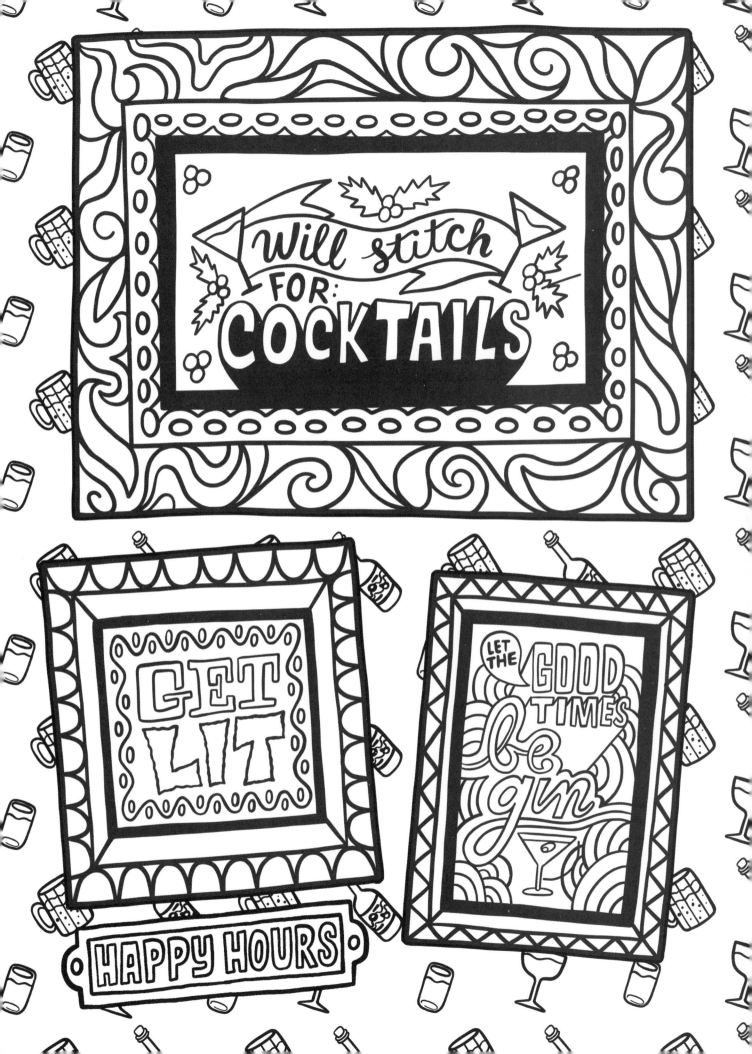

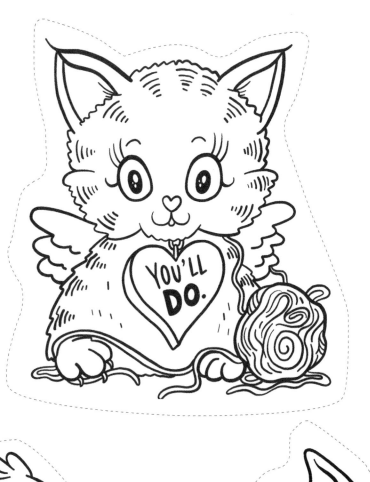

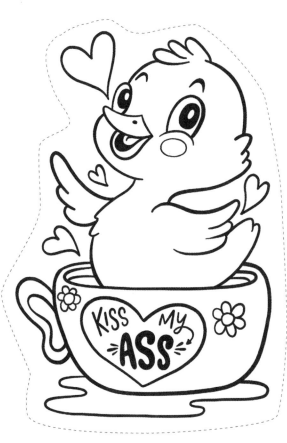

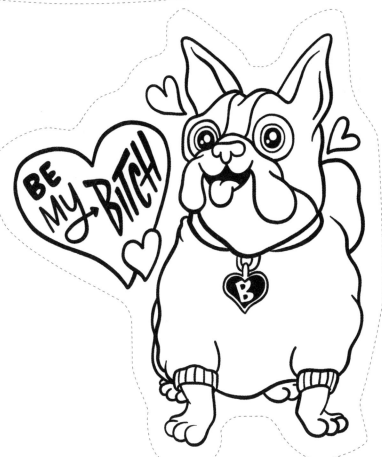

Everyday Valentines

Why wait until Valentine's Day to express
how you really feel? Cut these out and share
with whoever you have these kinds of feelings
for. Add your message on the back or just
let them think they have a secret admirer.

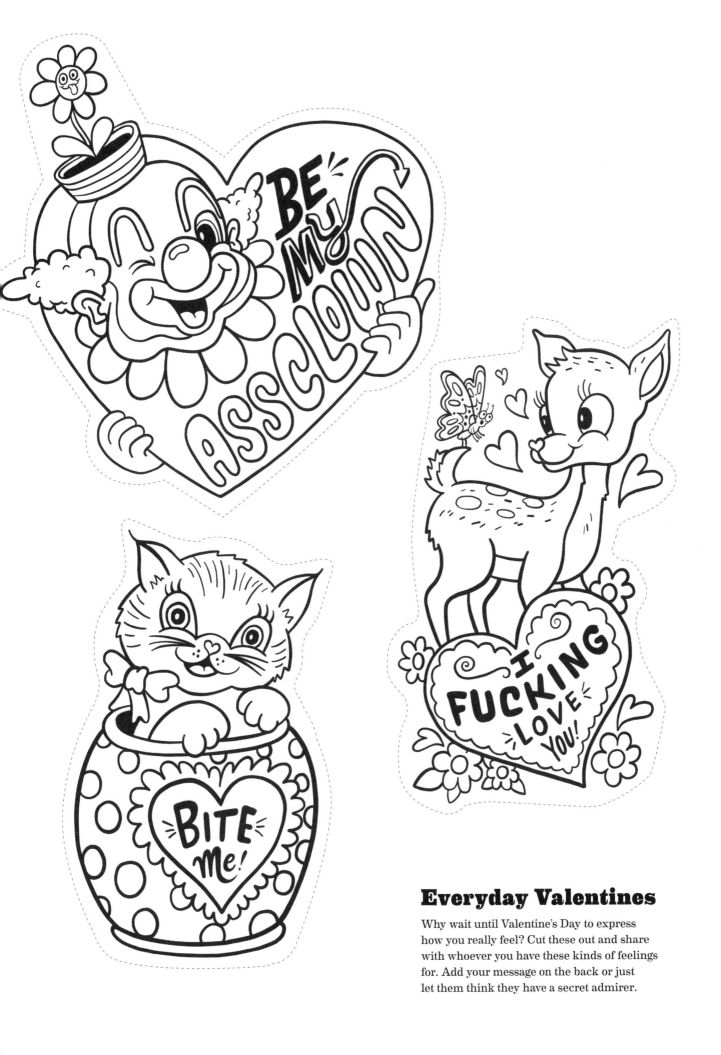

Everyday Valentines

Why wait until Valentine's Day to express
how you really feel? Cut these out and share
with whoever you have these kinds of feelings
for. Add your message on the back or just
let them think they have a secret admirer.

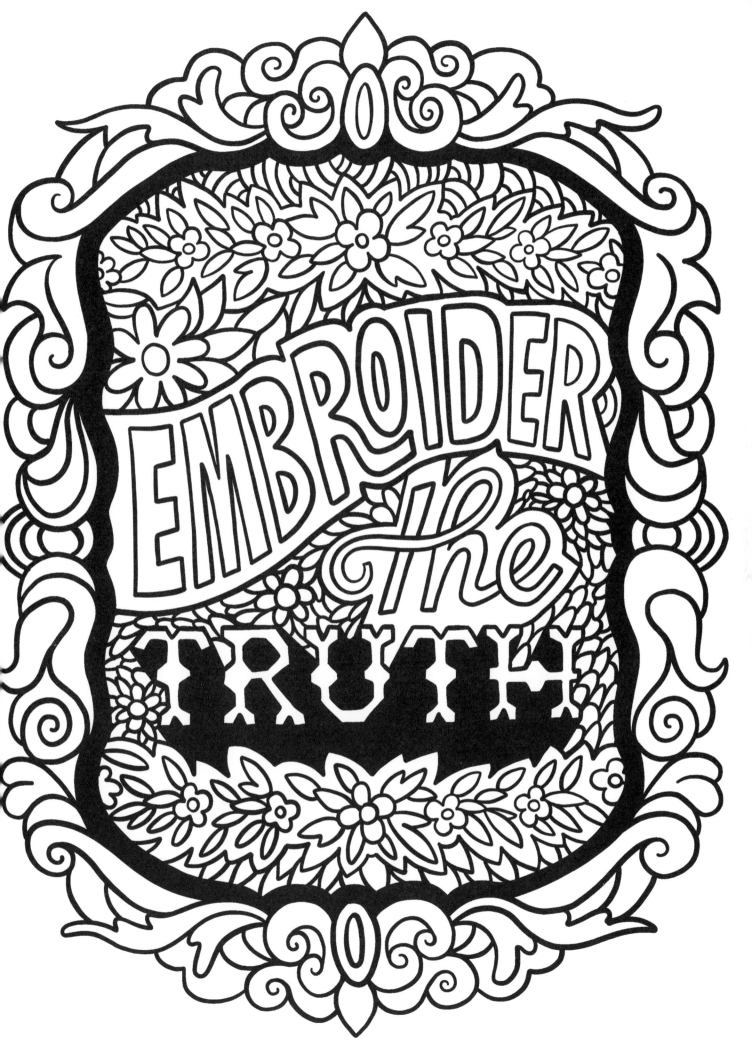

Flyer

Think of this as a public service. Color
in the poster art, cut the tabs to encourage
tear-offs then attach to a telephone pole
or bulletin board. Imagine participants
putting these in their pockets to get them
through the day. Your work here is done!

HAVING A BAD DAY?

TAKE ONE OF THESE,

TUCK IT IN YOUR

POCKET AND REMEMBER

IT'S NOT ALL

THAT BAD

brought to you by Subversive Cross Stitch

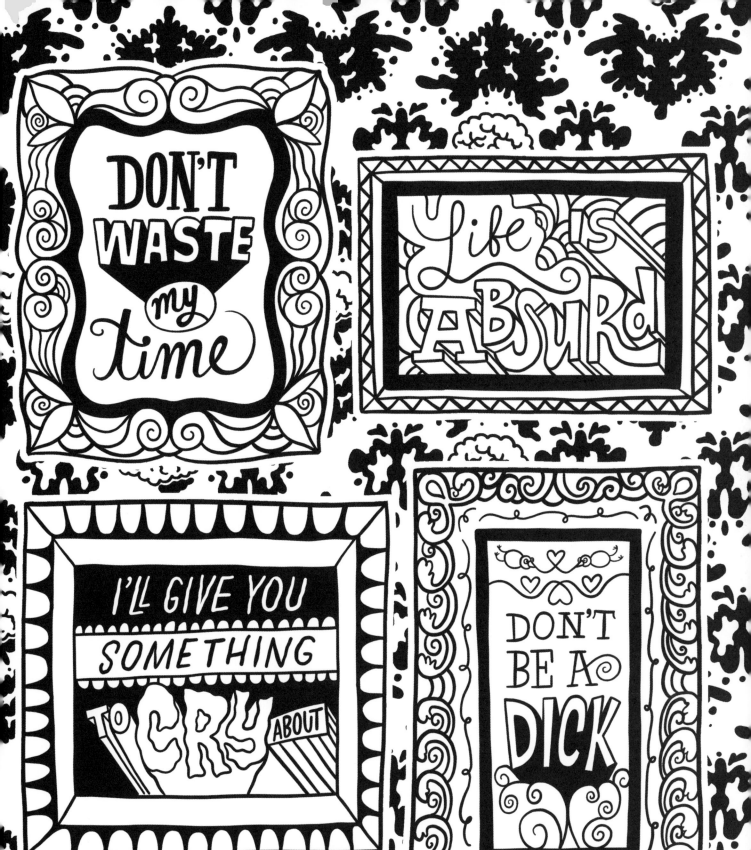

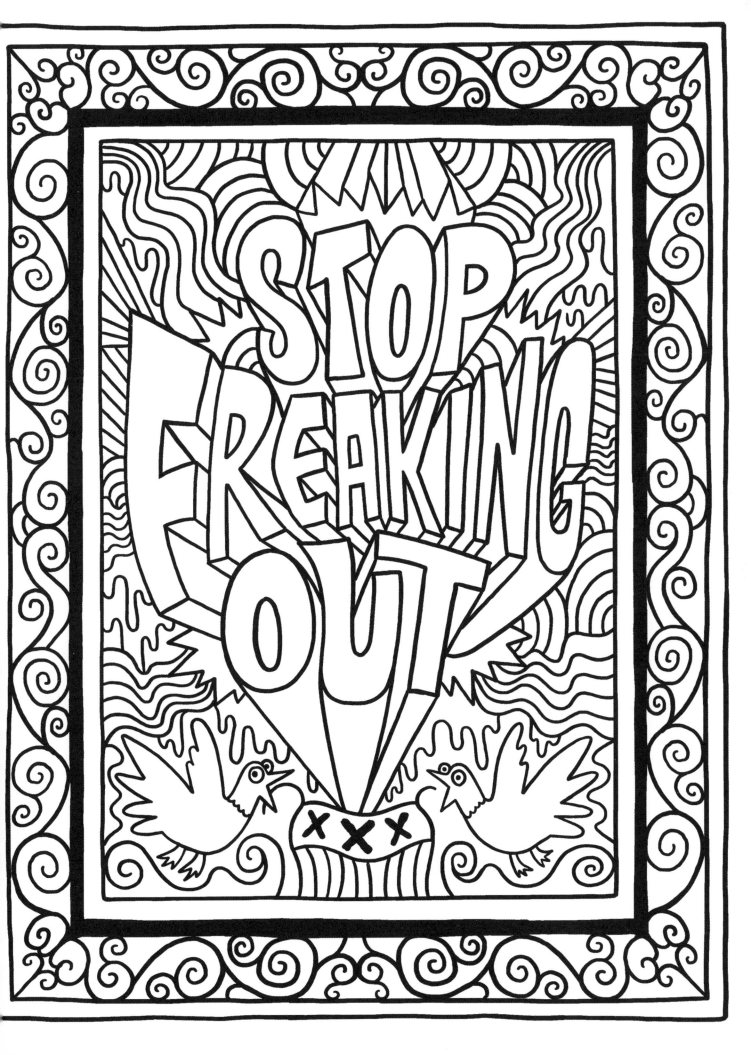

PAPER AIRPLANE

You know how these things work. A little simple
folding after adding your own snazzy color scheme
and you're off to the races. Aim at someone's head
for extra points.

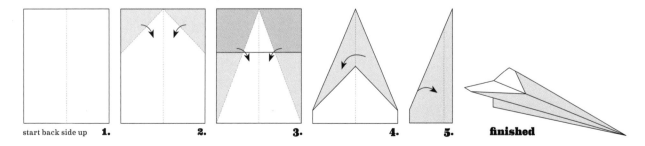

start back side up **1.** **2.** **3.** **4.** **5.** **finished**

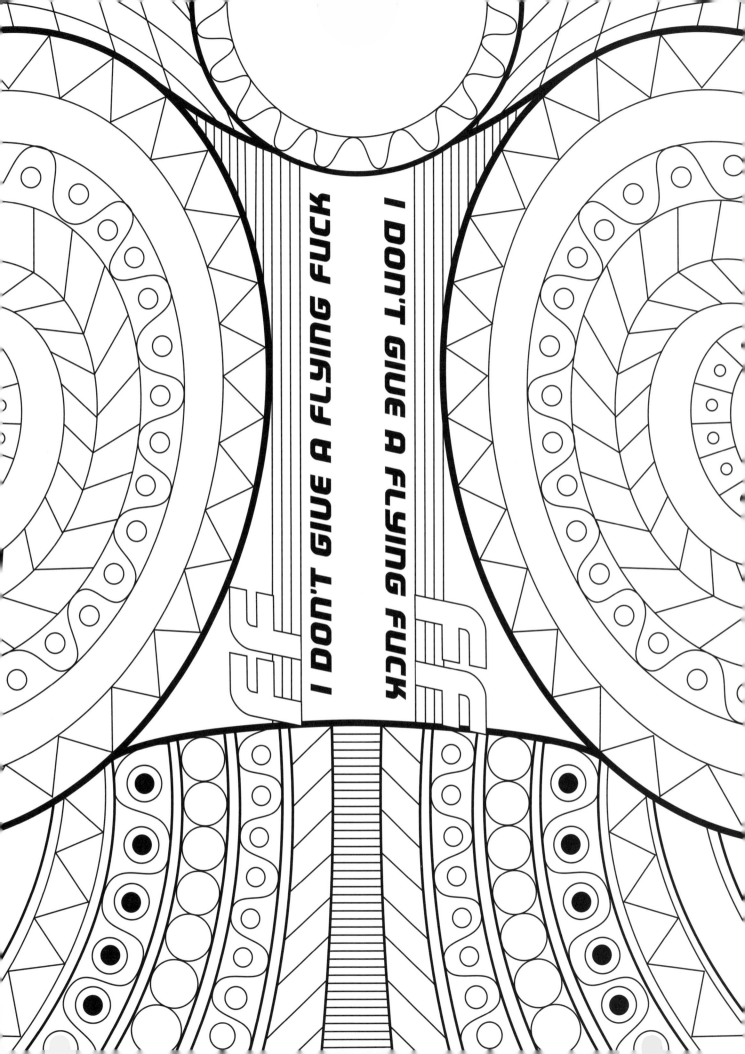

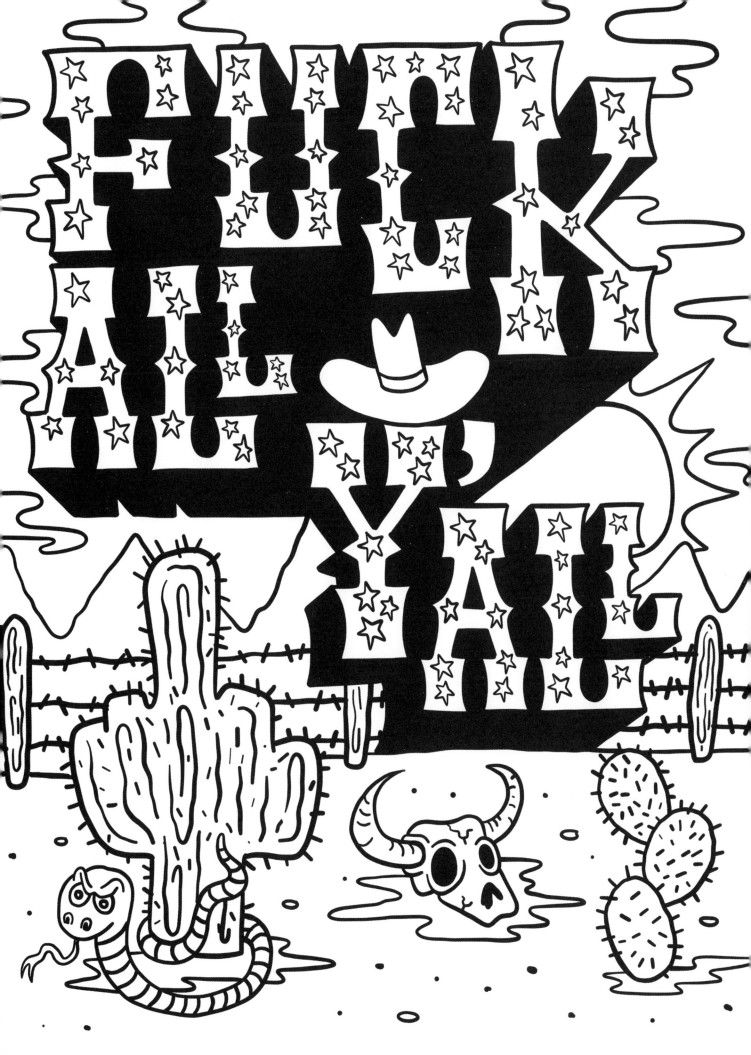

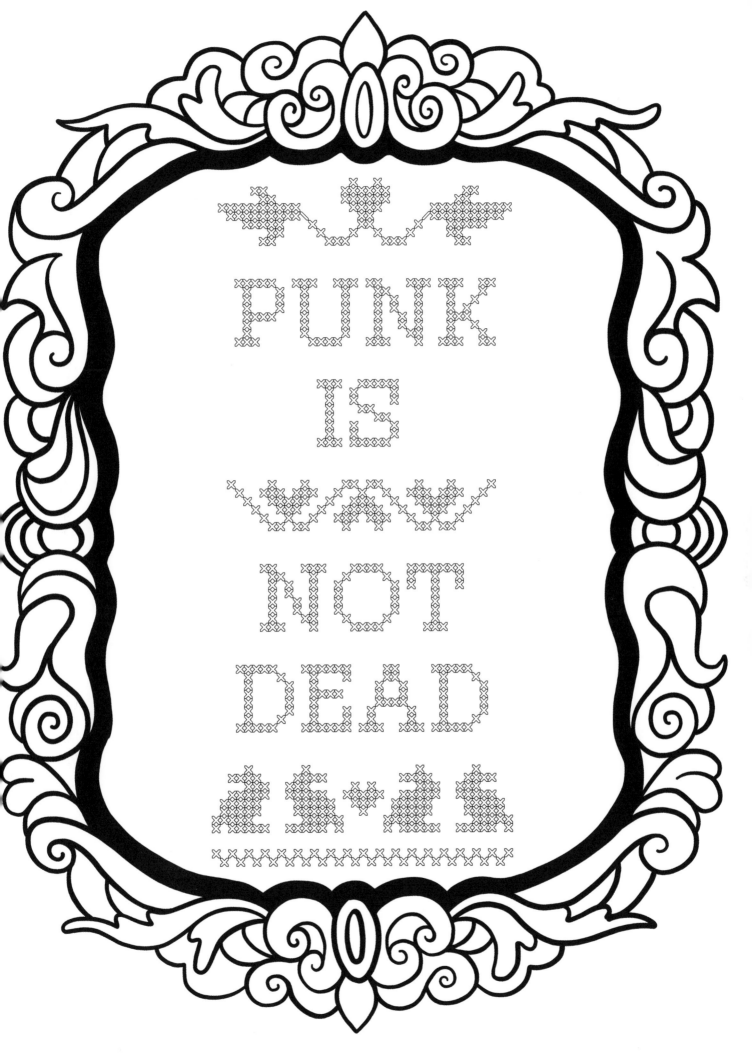

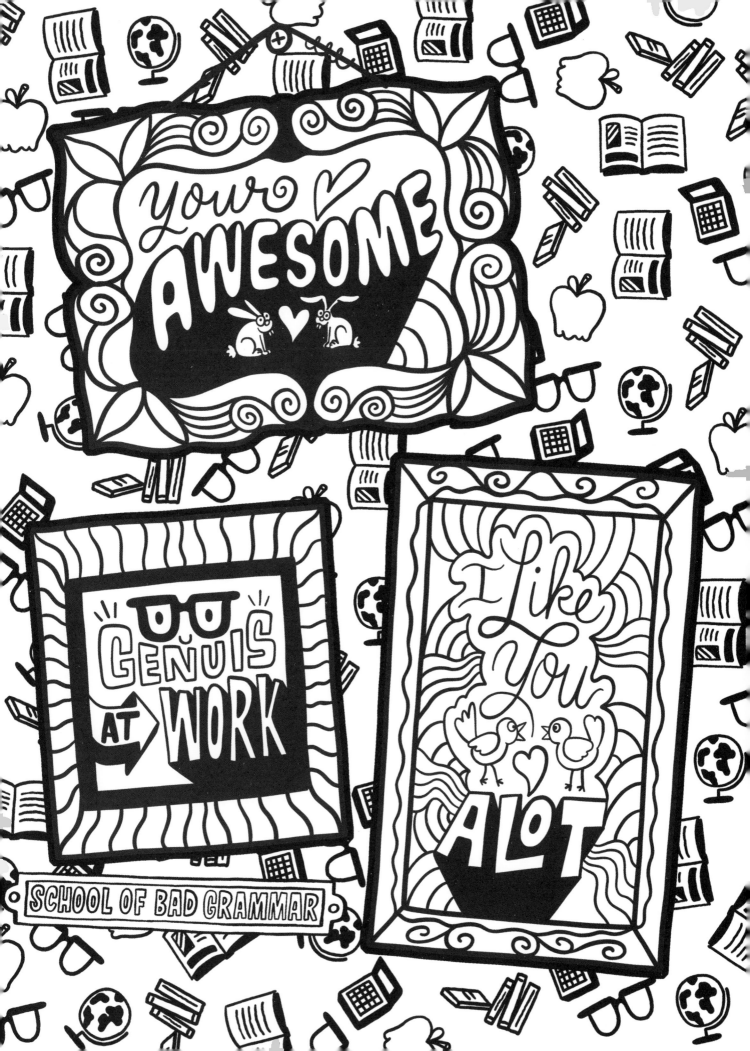

Subversive Cross Stitch

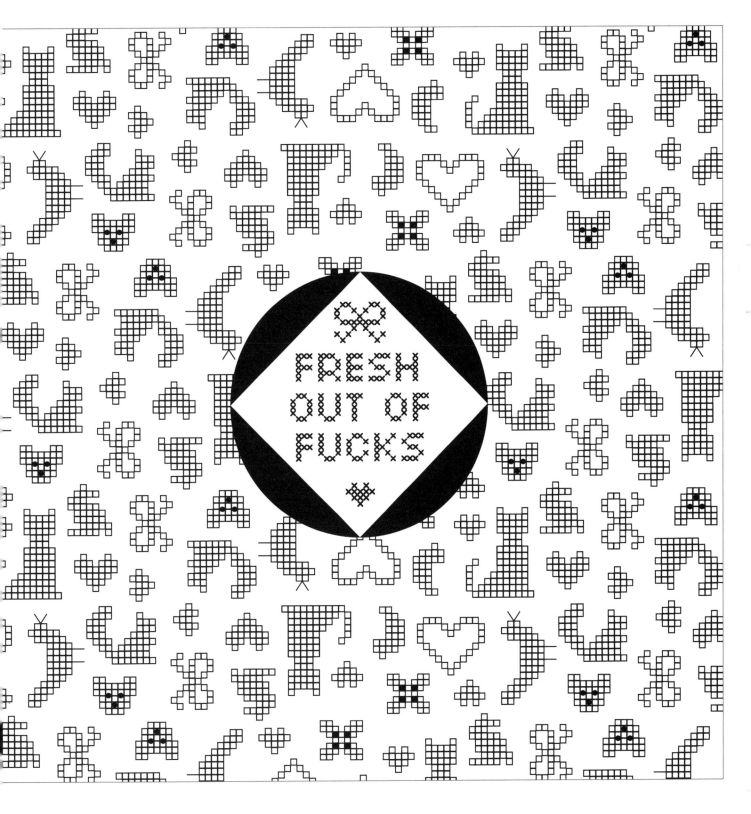

Origami Dish

This one is a little tricky, but imagine the look on their faces when they reach for a piece of candy and—OOPS!—you're fresh out of fucks! No more to give! Maybe tomorrow.

go to **http://bit.ly/freshoutoffucks**

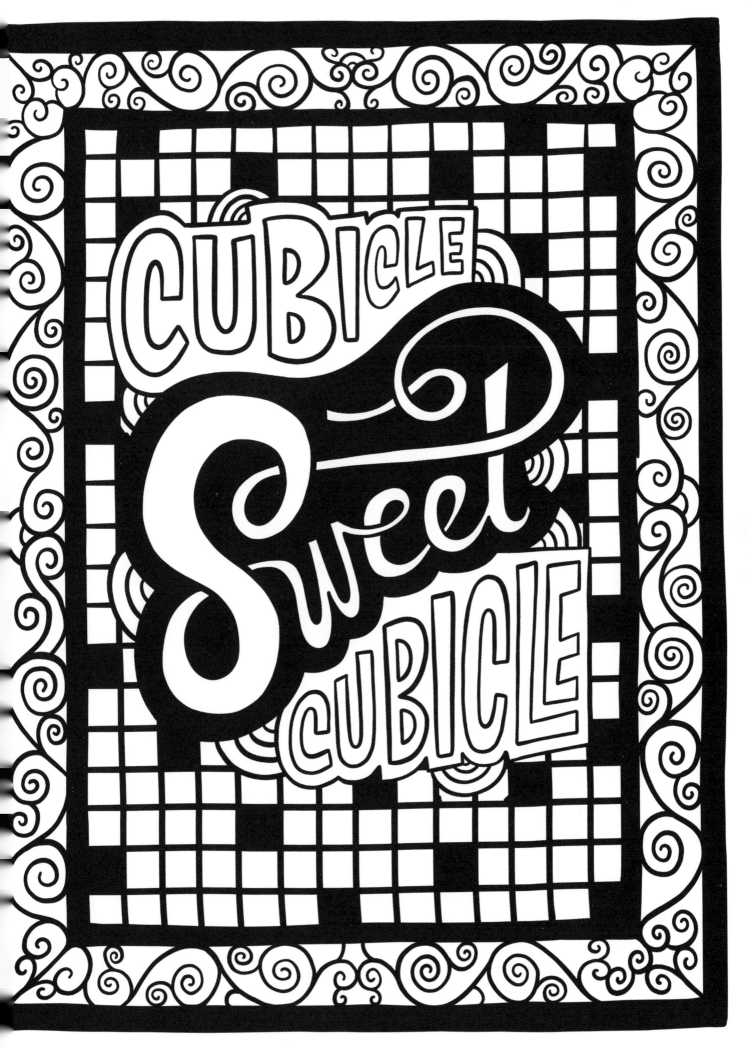

Back Door Guests Are The Best

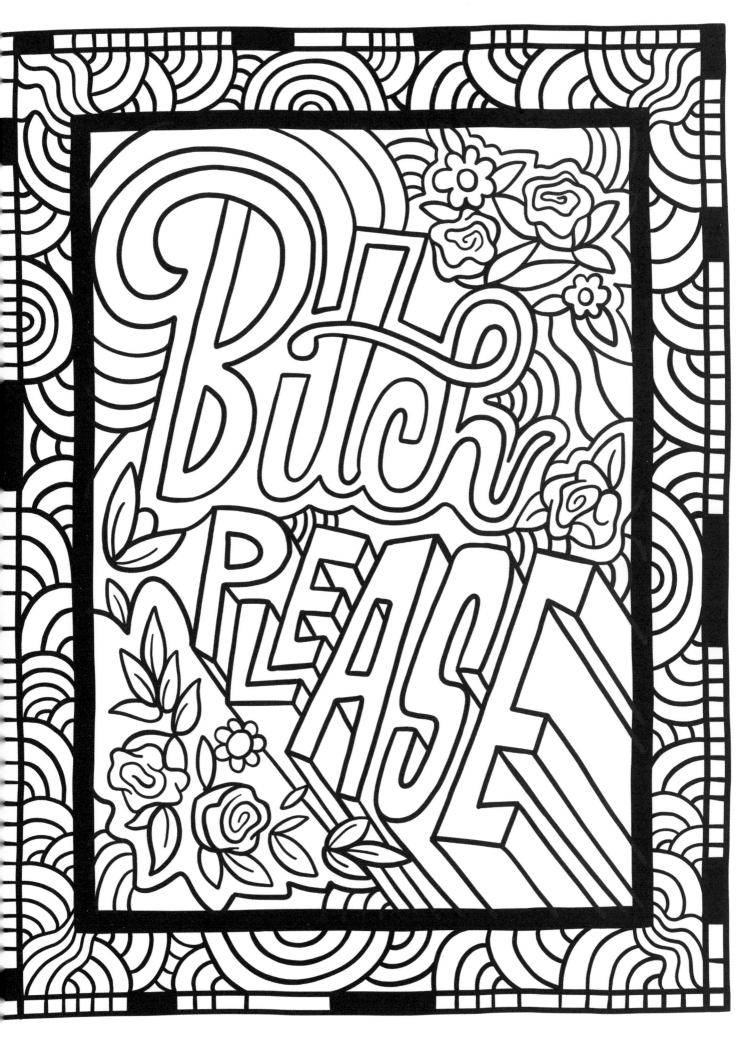

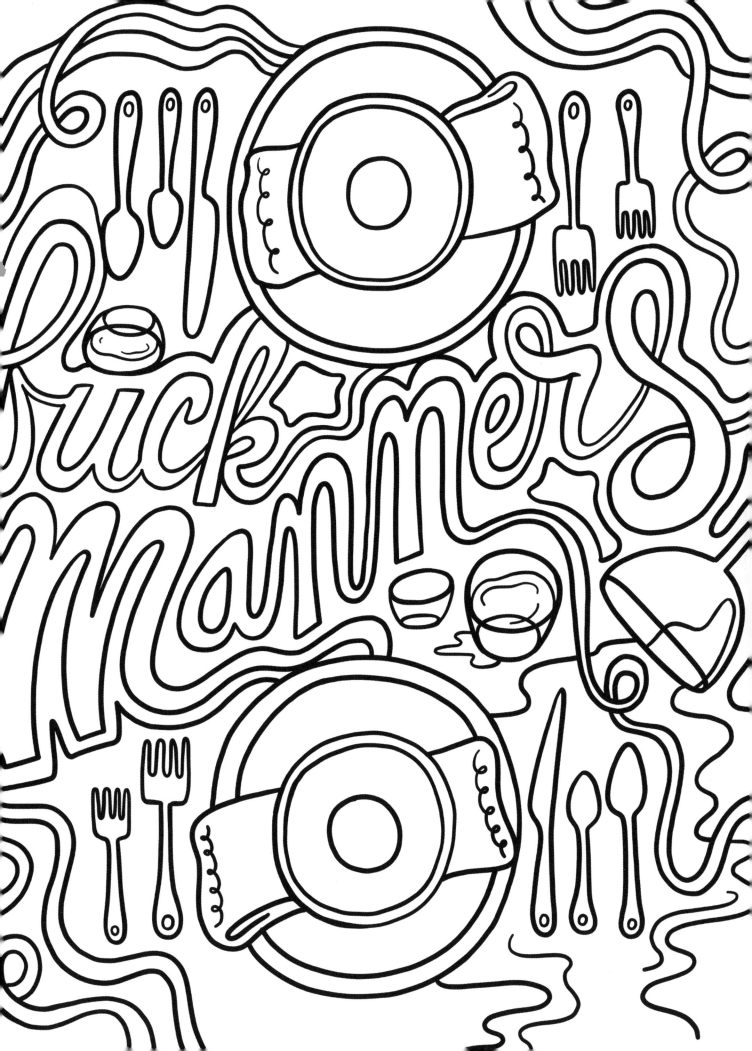

Fortune Teller

Surely you remember how this works from the playgrounds of your youth. Color the cross stitched images, then fill in the blank sections by writing in your own fortunes or using those suggested at right. Your friends will be so impressed with your adolescent skills and ability to predict the future. Depending on the situation, you can really play up the drama as suggested in our instructions.

If you need some help folding, here's a shortcut to a helpful video: **http://bit.ly/secretcatknowsall**

How to play:

1. Ask your ~~victim~~ friend to think of an important, potentially life-altering question for the fortune teller. Tell them to concentrate and dig deep.

2. Then ask them to pick one of the four outer images. Be sure to make an "mmmm" noise as if you think their choice is particularly meaningful, but don't explain why.

3. Spell out the name of the image and move the fortune teller in or out for each letter—I recommend you do this silently to increase the mystery. For example, if the person says "bunny," move the fortune teller out for "b," in for "u," and out again for "n", etc. Pause it in place where it lands. Make a mysterious, thoughtful noise under your breath as if you see something they can't.

4. Ask your friend to look into the "mouth" of the fortune teller and pick one of the smaller images that are visible. Once again, spell out the name of the image. Pause the fortune teller in place where it lands. Inhale sharply as if something is being revealed to only you.

5. Ask your friend to look into the fortune teller one last time and repeat step four. This time, all will be revealed so make a show of it! Open the flap dramatically and read the fortune that goes with that image.

6. If you really want to show off, you can make up a story about the cat inside the fortune teller and reveal that image to your friend. Something like, "It's a cat, but not *just* a cat, and it's from the future. YOUR future!"

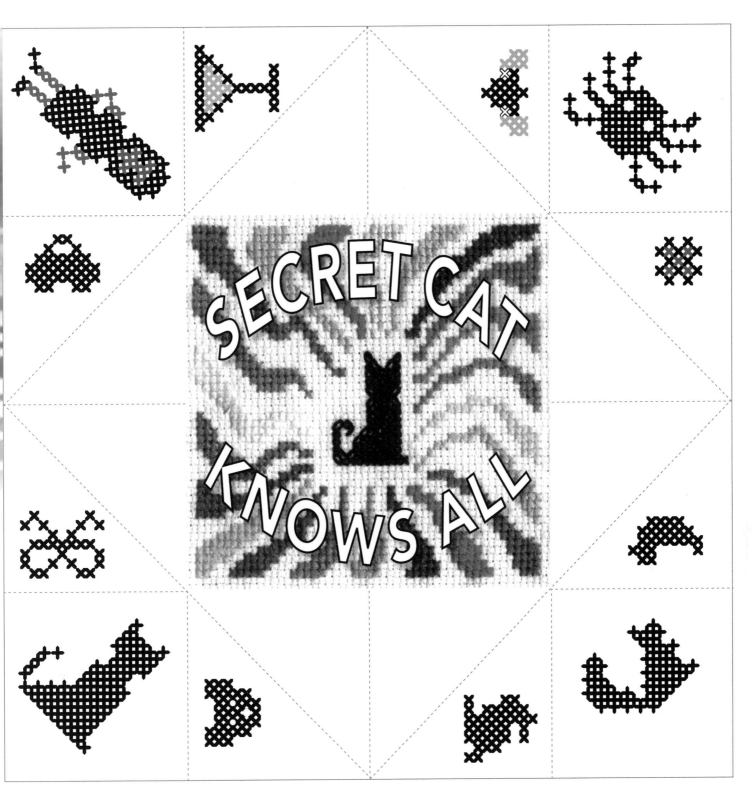

Suggested fortunes:

Try Again
Drinks are on you
Fuck off
The answer is NO
NOPE.
Your future is blight
Abso-fucking-lutely
In Bed

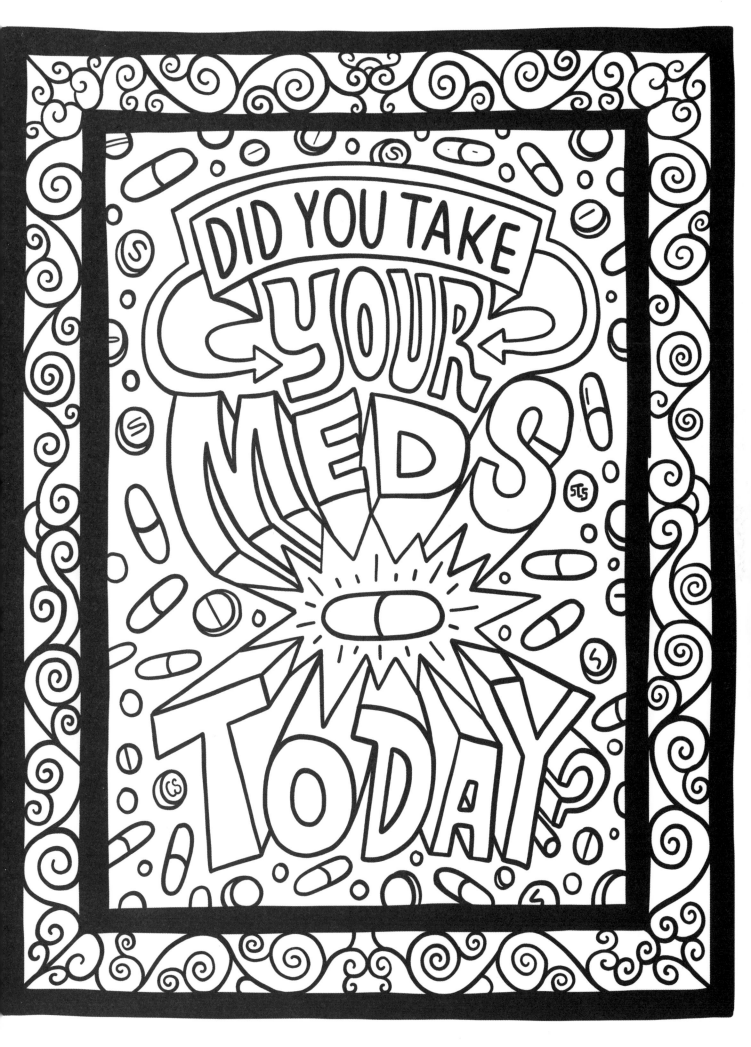

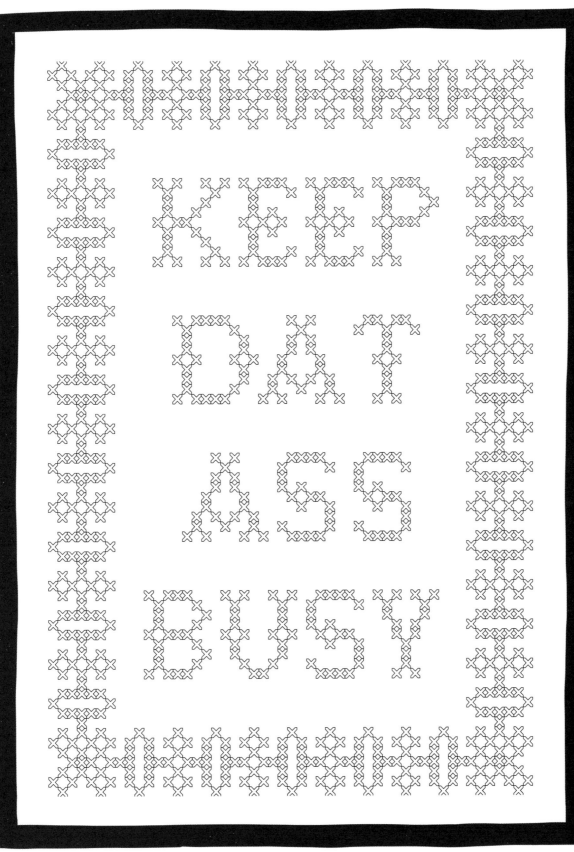

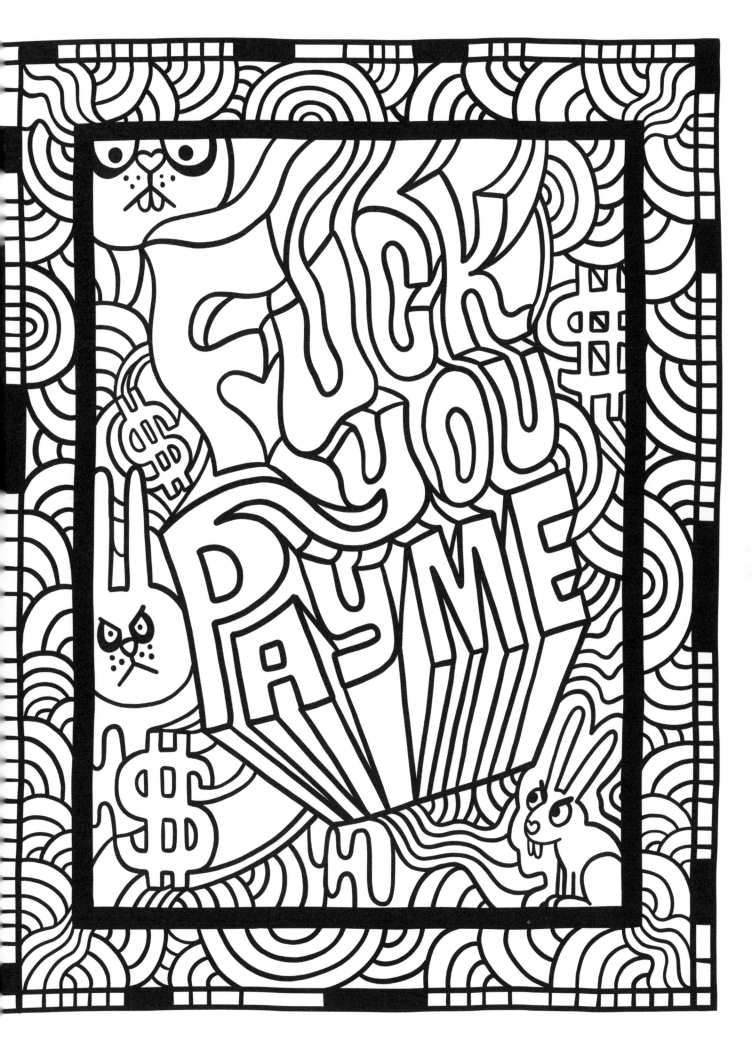

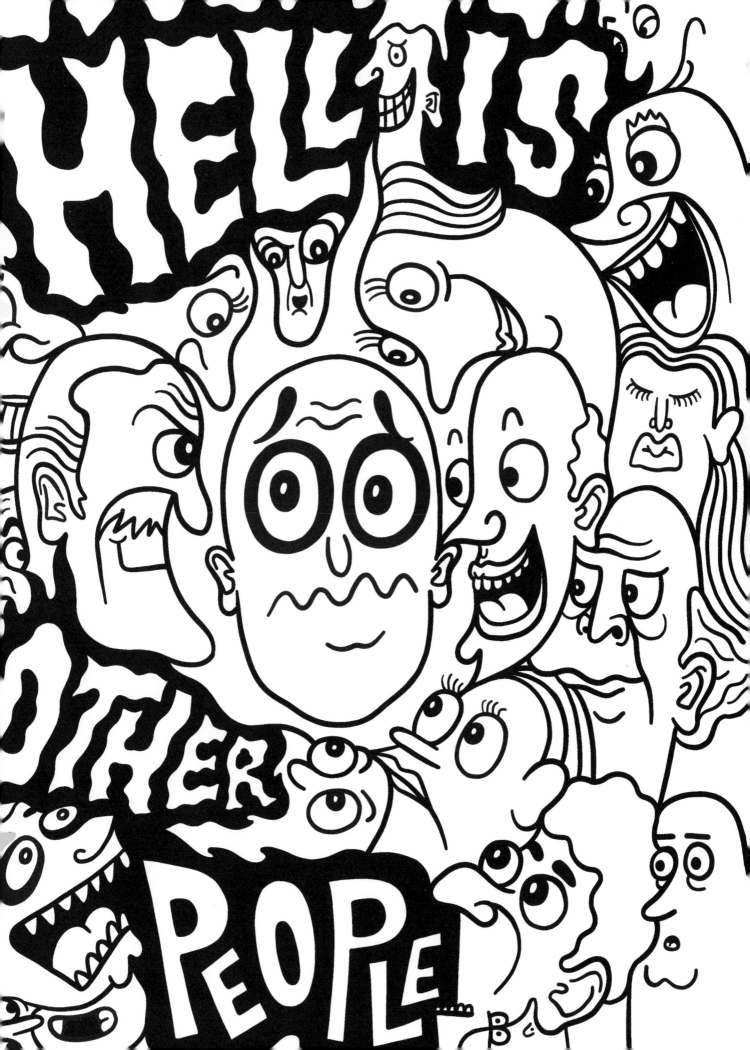

It's
lavish,
but I
call it
HOME

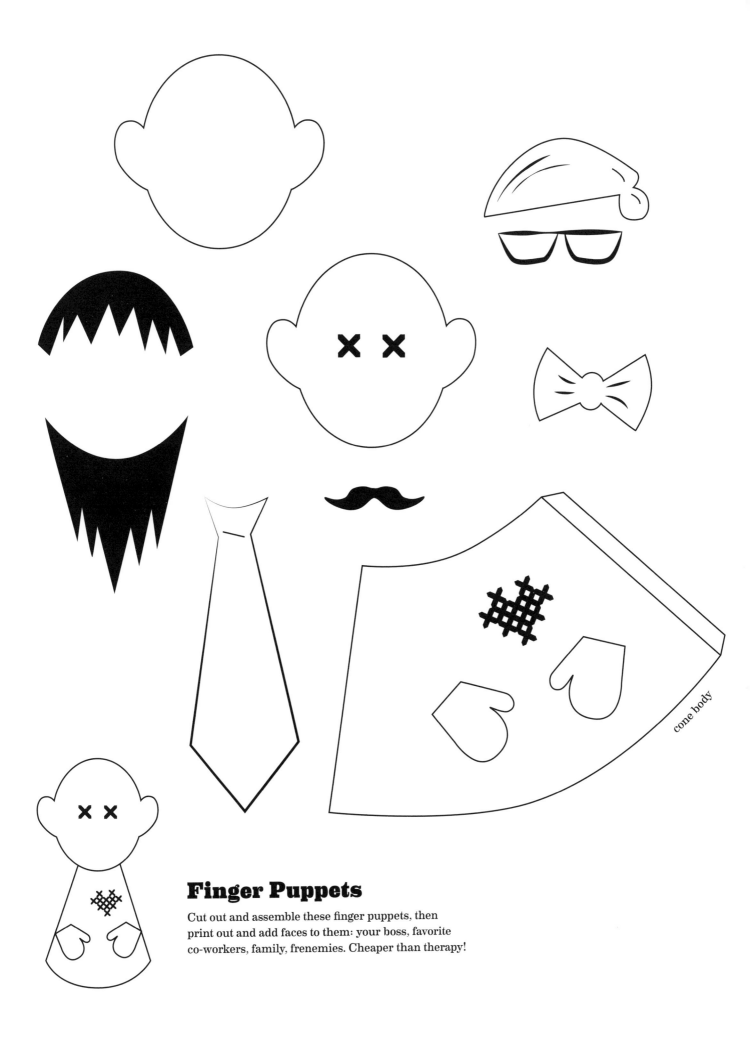

Finger Puppets

Cut out and assemble these finger puppets, then
print out and add faces to them: your boss, favorite
co-workers, family, frenemies. Cheaper than therapy!

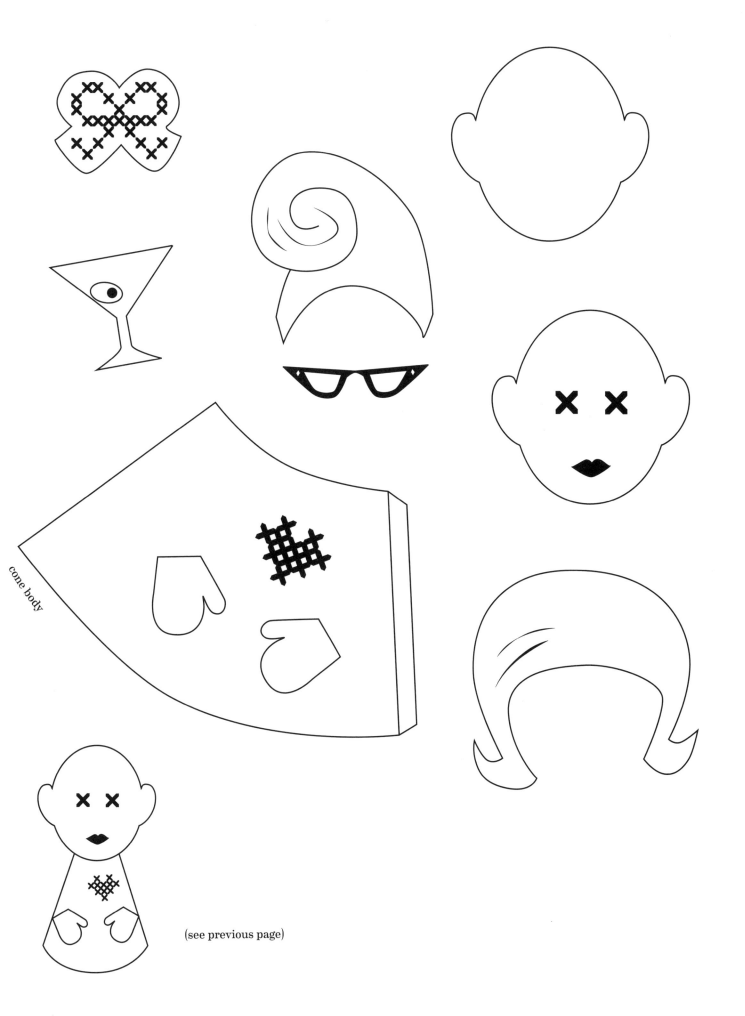

cone body

(see previous page)

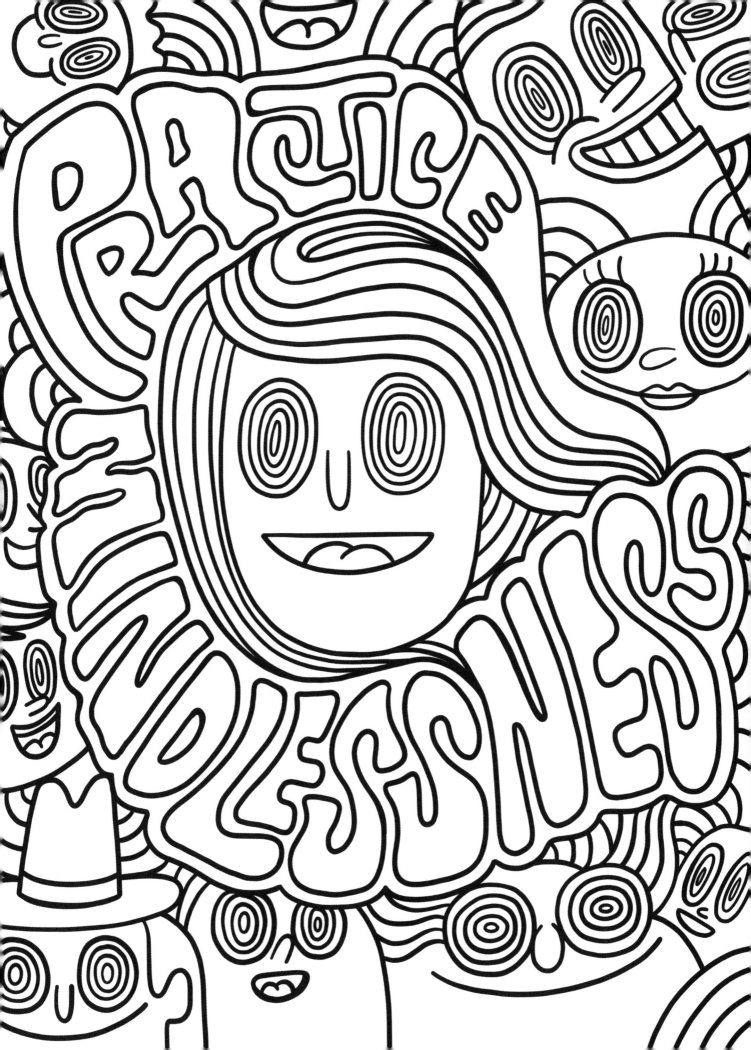

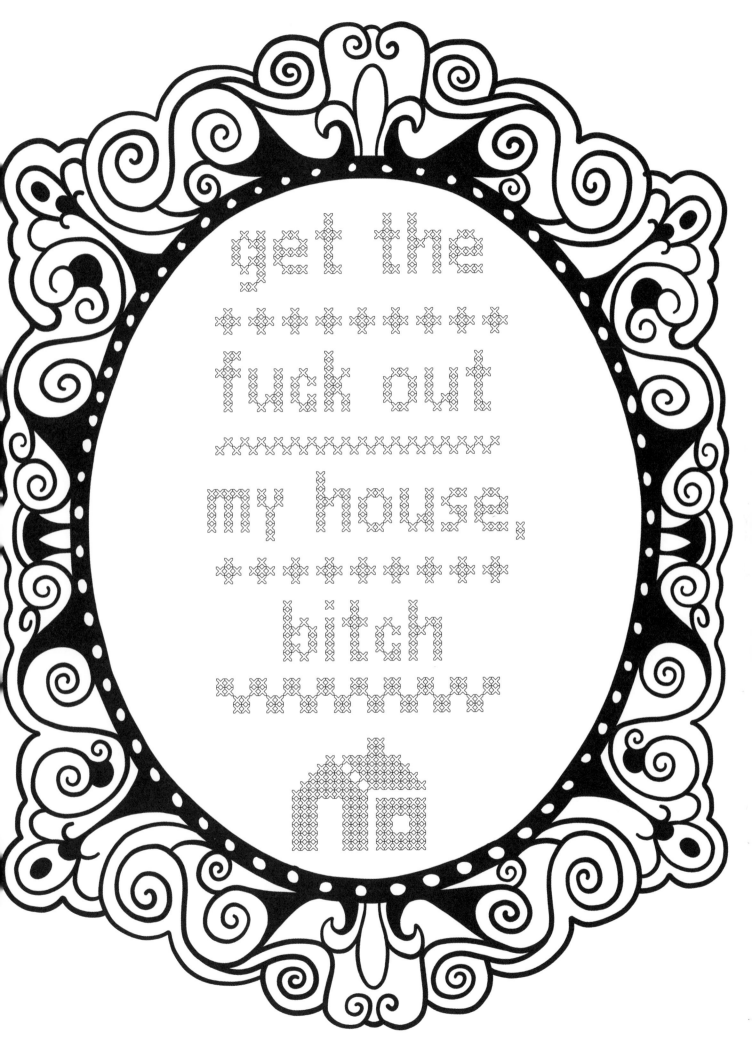

≡Bluestreak

an imprint of Weldon Owen
1045 Sansome Street, San Francisco, CA 94111
www.weldonowen.com
Weldon Owen is a division of Bonnier Publishing USA

Library of Congress Cataloging in Publication data is available.

Produced by Blue Sky Books
Project Manager/Editor: Dan Tucker
Designer: Celia Fuller

ISBN-13: 978-1-68188-179-9

First Printed in 2017

10 9 8 7 6 5 4 3 2 1

2017 2018 2019 2020

Printed in China

About the Author

In 2003, **Julie Jackson** created Subversive Cross Stitch, a bedrock of the modern craft movement that pairs old-fashioned samplers with snarky sentiments. Her 2015 book *Subversive Cross Stitch: 50 F*cking Clever Designs For Your Sassy Side* has been the #1-selling cross stitch book on Amazon since its release. Kits, supplies, advice, and hundreds of PDF patterns can be found on her site, subversivecrossstitch.com. Julie is also the creator of Kitty Wigs, an early contender in the online world of cat memes (kittywigs.com).

Also by Julie Jackson:

Marie Catoinette: Kitty Wigs Presents A Cautionary Tale of Excess: An Historically Imaginative Adult Coloring Book

*Subversive Cross Stitch: 50 F*cking Clever Designs For Your Sassy Side*

Subversive Cross Stitch: 33 Designs for Your Surly Side

Glamourpuss: The Enchanting World of Kitty Wigs

About the Illustrator

After starting his career as a graphic designer at award-winning studios in New England, **Chris Piascik** accidentally became an illustrator. He's pretty happy about that. This strange transformation was a result of his daily drawing project that he started in late 2007; in fact he's still posting a new drawing every day. In addition to those drawings, he makes other drawings for clients such as Coca-Cola, Nike, Ogilvy, Nickelodeon, and others. Chris received his MFA in Illustration, and BFA in Visual Communication Design from the University of Hartford's Hartford Art School.